Women of the Ukiyo-e

Ming-Ju Sun

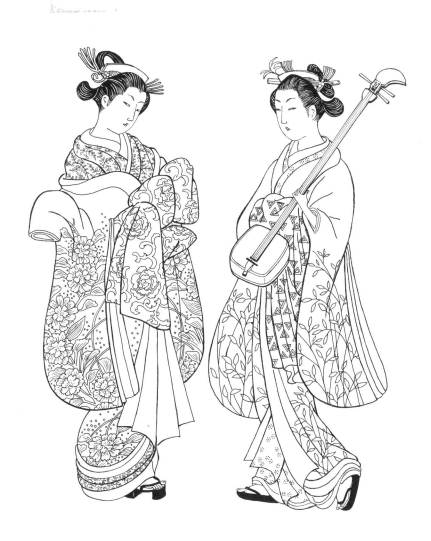

DOVER PUBLICATIONS, INC.
Mineola, New York

NOTE

Ukiyo-e woodblock prints and paintings are among the most widely known and admired arts of the Edo period (1615–1867) in Japan. *Ukiyo,* which translates as "the floating world," was the name given to the sophisticated and affluent lifestyle in Japan's urban centers. Ukiyo-e art, or "pictures of the floating world," is most closely associated with the pleasures of theaters, restaurants, teahouses, geisha, and courtesans. Many ukiyo-e prints by such artists as Utamaro were actually posters, advertising theater performances and brothels, or portraits of actors and beautiful teahouse women. The manners and customs of ordinary life became the primary focus of these artists, and pictures of beautiful women *(bijin-ga),* soon became a very popular subject.

Adapted for coloring by artist Ming-Ju Sun, the thirty prints in this book are exquisite black-and-white renderings of the feminine ideal in Japanese ukiyo-e art. Eleven color plates appear on the covers.

Bibliographical Note

Women of the Ukiyo-e is a new work, first published by Dover Publications, Inc., in 2004.

DOVER *Pictorial Archive* SERIES

This book belongs to the Dover Pictorial Archive Series. You may use the designs and illustrations for graphics and crafts applications, free and without special permission, provided that you include no more than four in the same publication or project. (For permission for additional use, please write to Permissions Department, Dover Publications, Inc., 31 East 2nd Street, Mineola, N.Y. 11501.)

However, republication or reproduction of any illustration by any other graphic service, whether it be in a book or in any other design resource, is strictly prohibited.

International Standard Book Number: 0-486-43332-3

Manufactured in the United States of America
Dover Publications, Inc., 31 East 2nd Street, Mineola, N.Y. 11501

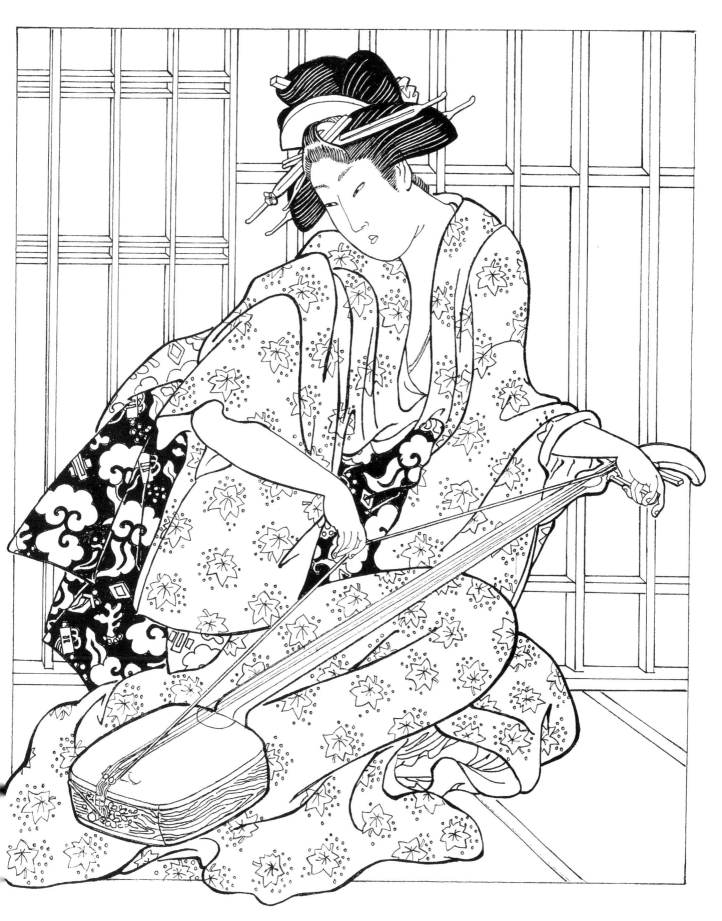

Kiyomine (1787–1868). "Contemporary Flowers of the Four Seasons." The season of summer is represented by the beauty tightening the strings of her samisen (3-stringed guitar).

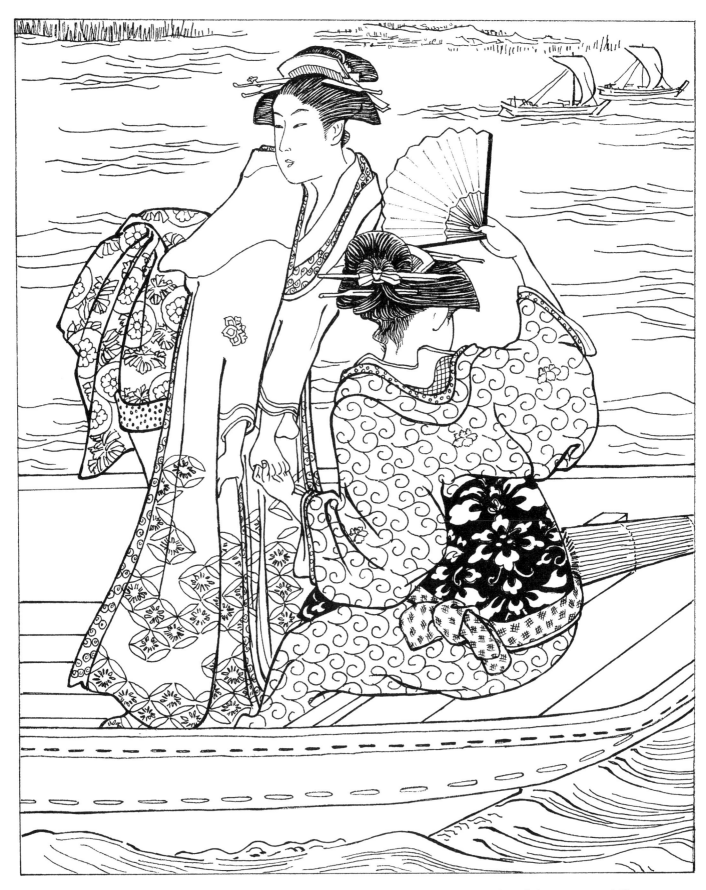

Kiyonaga (1752–1815). "Ferry Over the Sumida." An example of the artist's skill, this scene combines a background of natural scenery with human figures.

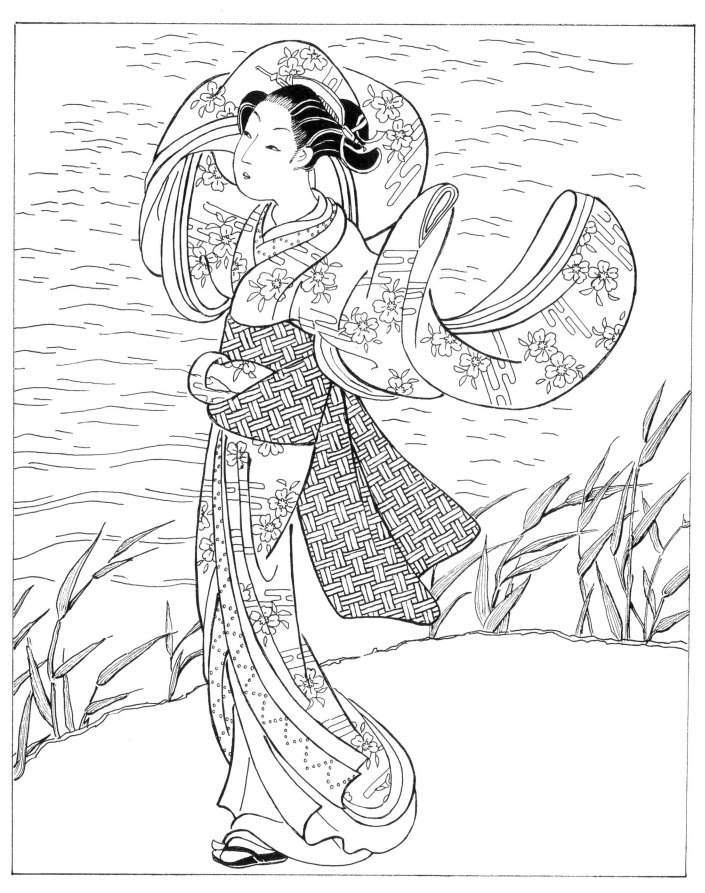

Harunobu (1725–1770). "A Beauty Bidding Bon Voyage." The graceful fluttering of flowing sleeves shows off the beautiful kimono and enhances the charming scene.

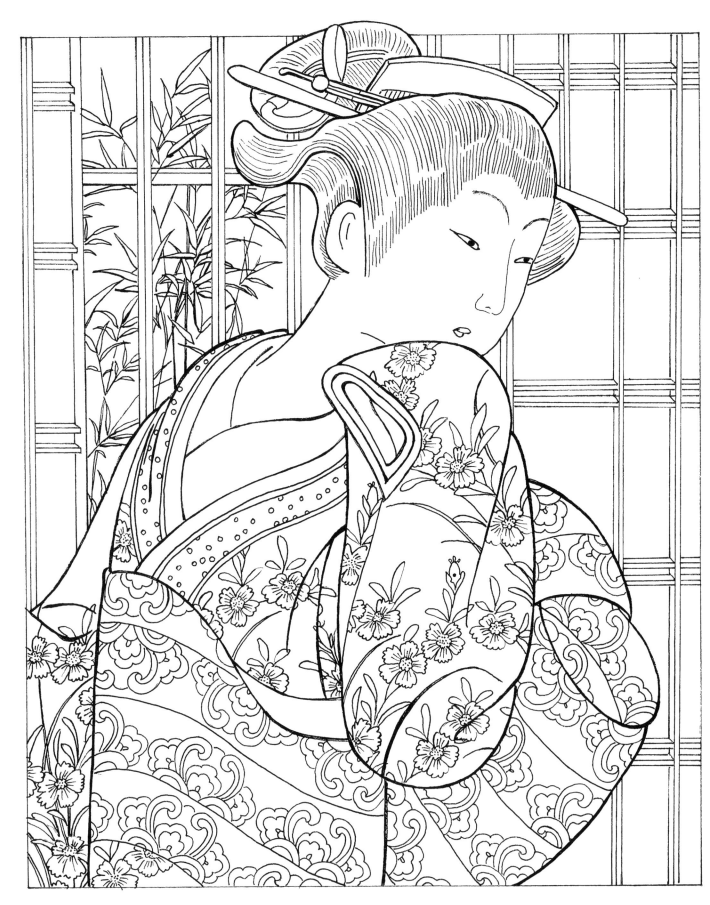

Buncho (active c. 1770–1780). "Osen of Kagi-Ya" *(detail)*. This young beauty serves tea in a popular teahouse. Buncho beauties influenced many other artists who also produced beauty prints.

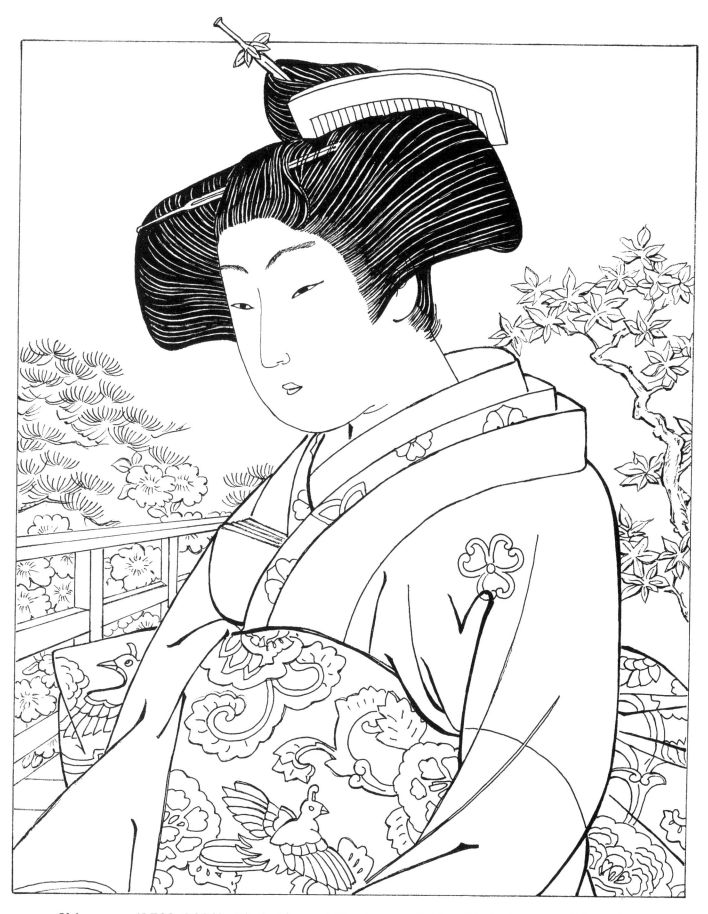

Shigemasa (1739–1820). "A Geisha and Her Servant" *(detail)*. A close-up of the print shows the way the artist depicted the hairstyle that was popular at that moment.

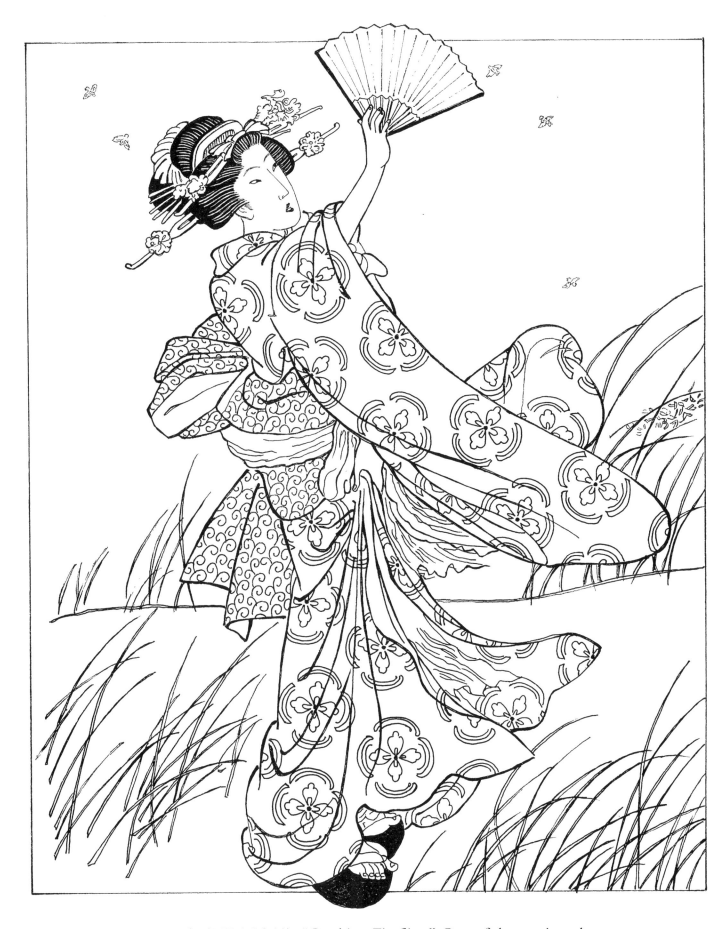

Kunisada (1786–1864). "Catching Fireflies." One of three prints that
depict women playing with fireflies on a warm summer night.

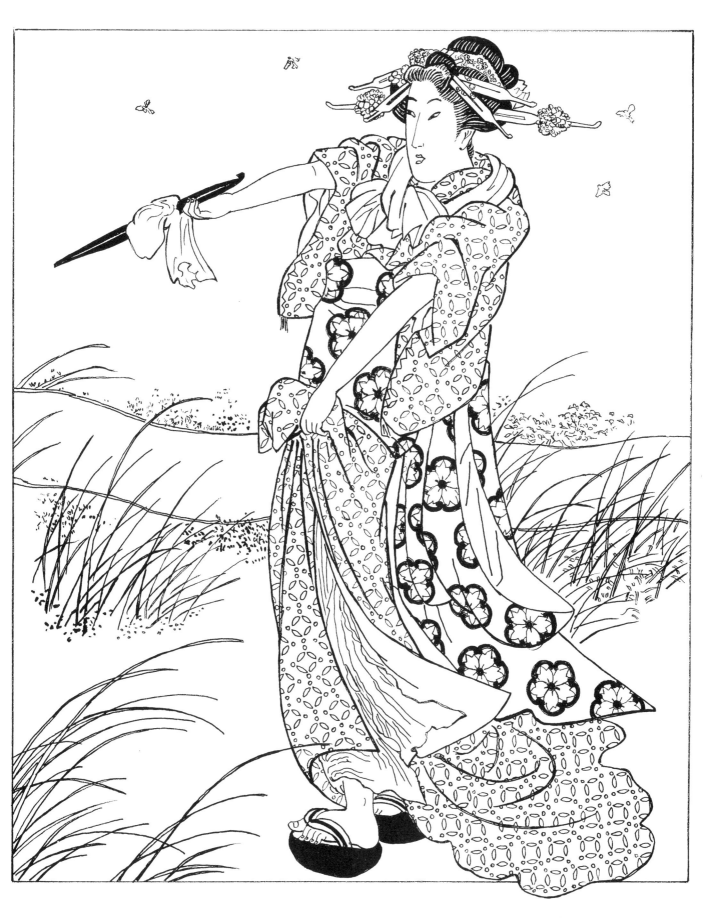

Kunisada (1786–1864). "Catching Fireflies." This second print in the three-print series, *triptych*, shows another woman watching fireflies. Each print can stand as an independent work; the only connection between them is the background.

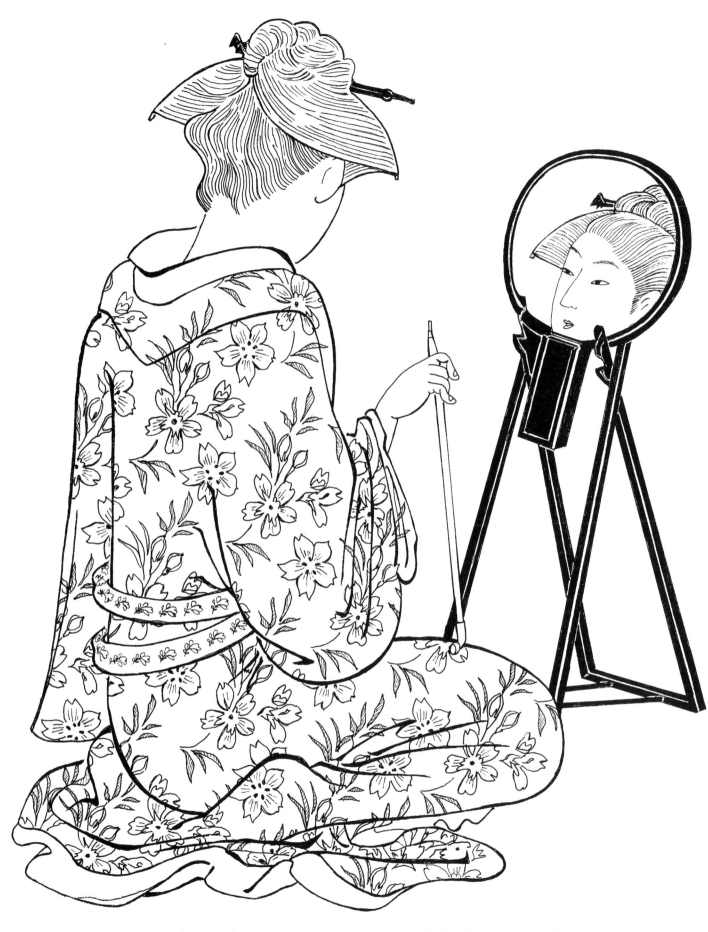

Kiyonaga (1752–1815). "Contemporary Beauties of the Gay Quarters." Kiyonaga's
beauties in his prints from 1781 to 1785 came to rule the Ukiyo-e world unchallenged.

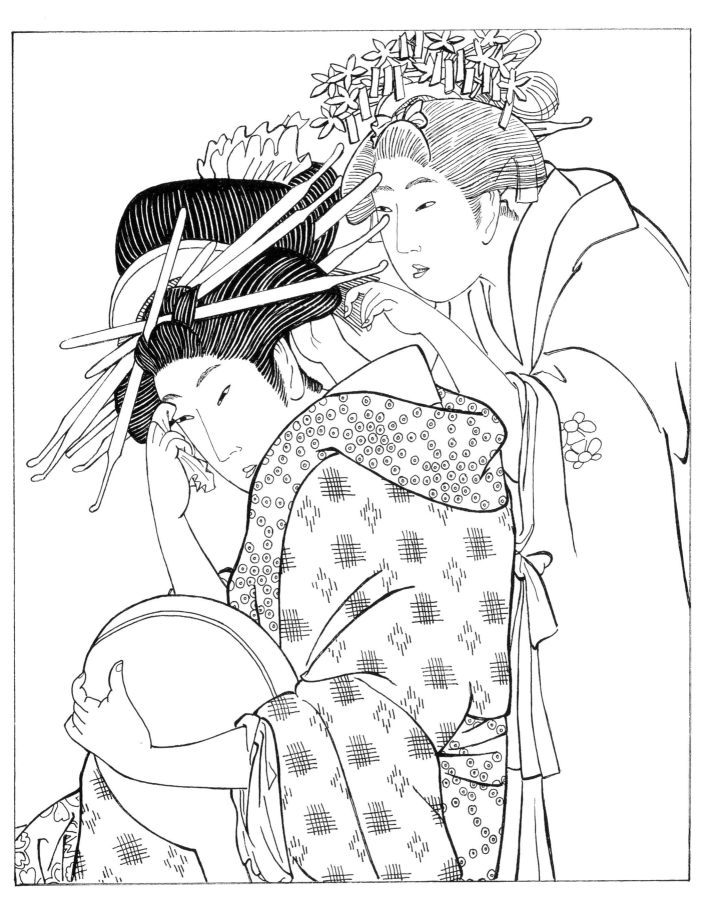

Utamaro (1753–1806). "The Oiran Yoso-oi Seated at Her Toilet." The woman is looking at herself in the lacquered mirror while her attendant puts the finishing touches to her elaborate hairdo.

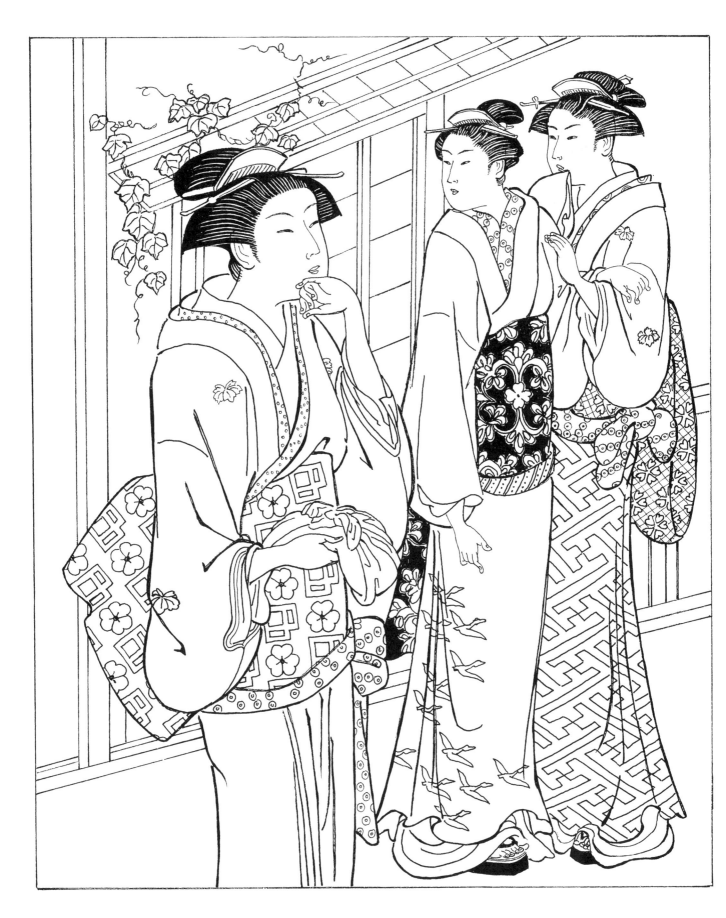

Kiyonaga (1752–1815). "Miai at the Shrine." These three women are typical Kiyonaga beauties of the period—tall, slender, and elegant in beautiful flowing kimonos.

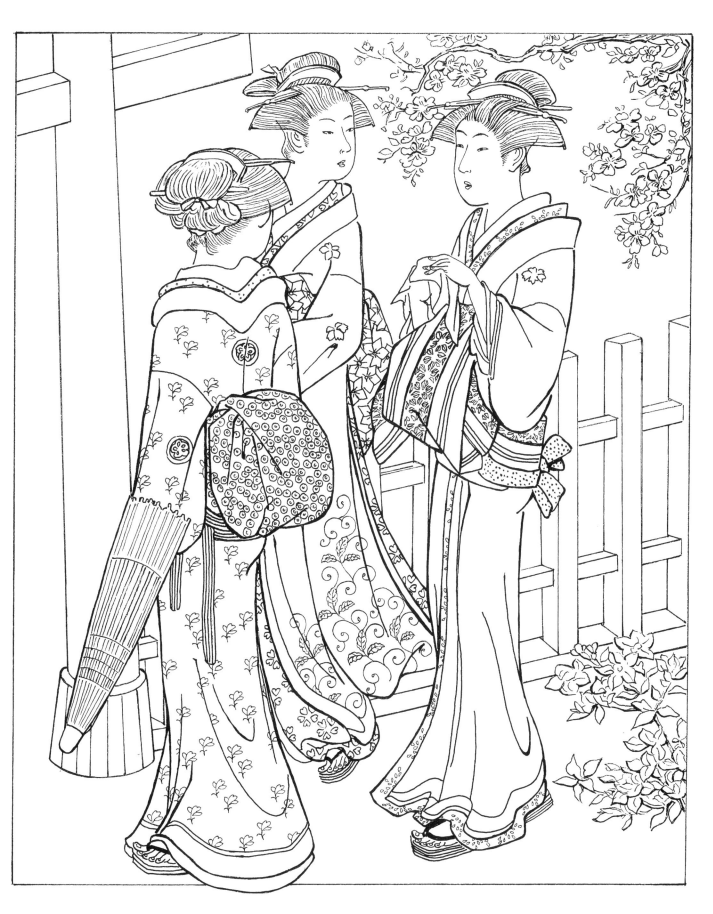

Kiyonaga (1752–1815). "Eight Spots Around the Great Temple of Asakusa." Three women visit popular shrines and shopping areas in the Asakusa district of Edo.

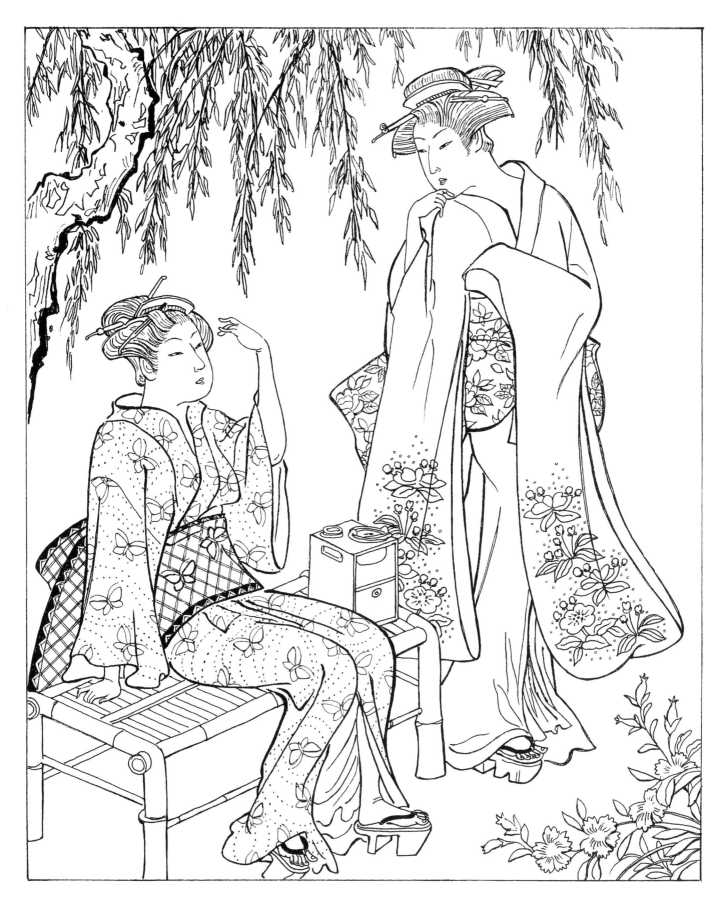

Kiyonaga (1752–1815). "A Collection of Beauties in Costume." Two women, seen in the latest kimono designs, are relaxing in the garden on a summer evening.

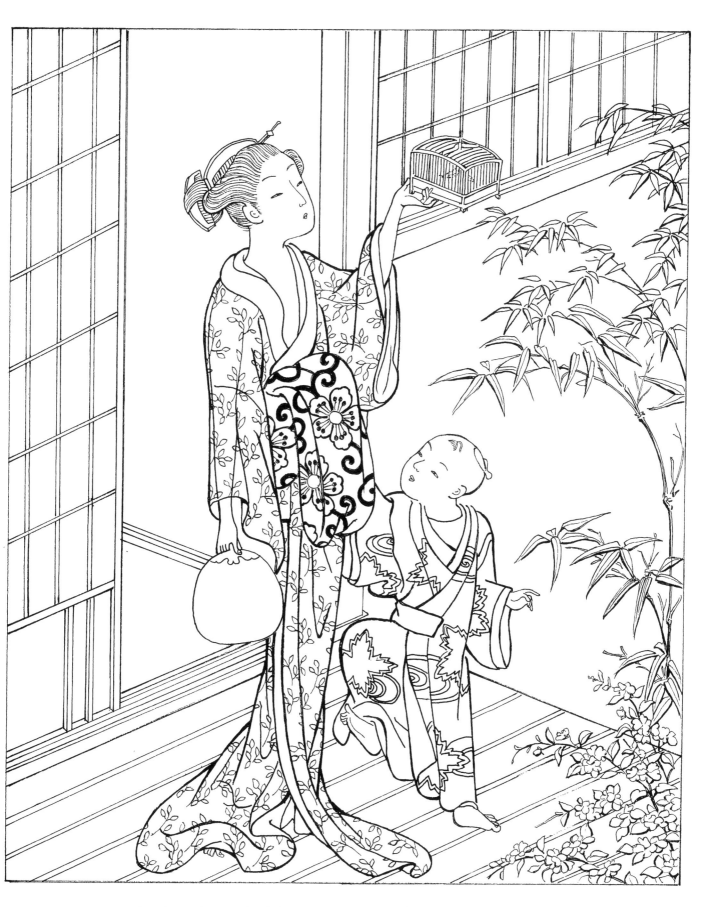

Harunobu (1725–1770). "The Insect Cage and the Child." The Japanese have always loved the many different insects that sing in summer and autumn.

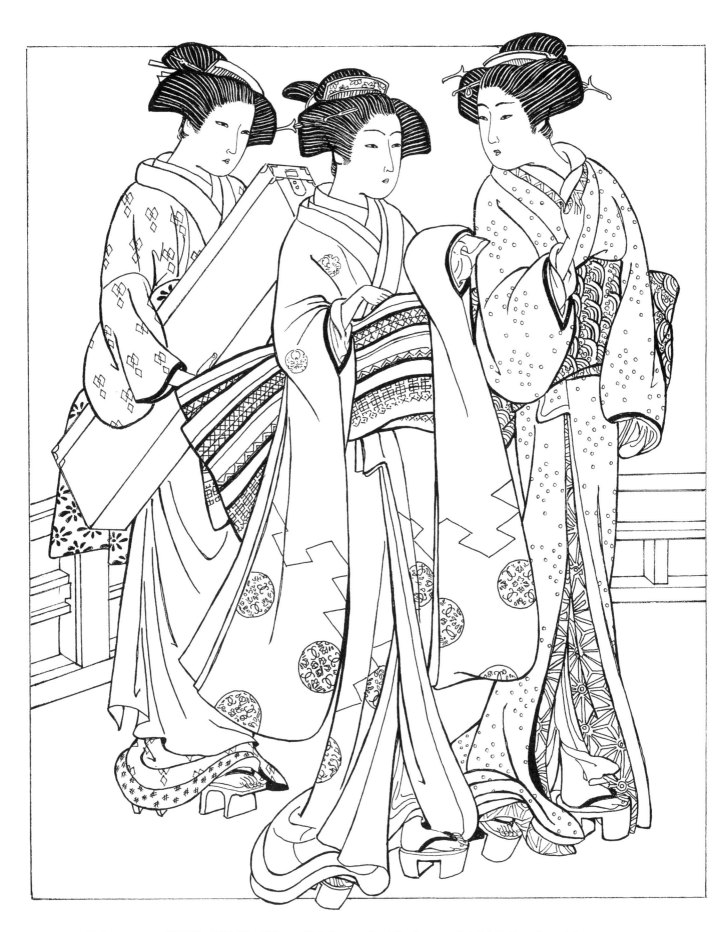

Shigemasa (1739–1820). "Two Geisha and a Teahouse Maid." Depicted here are two geisha attended by a maidservant holding a samisen (3-stringed guitar) case in her arms.

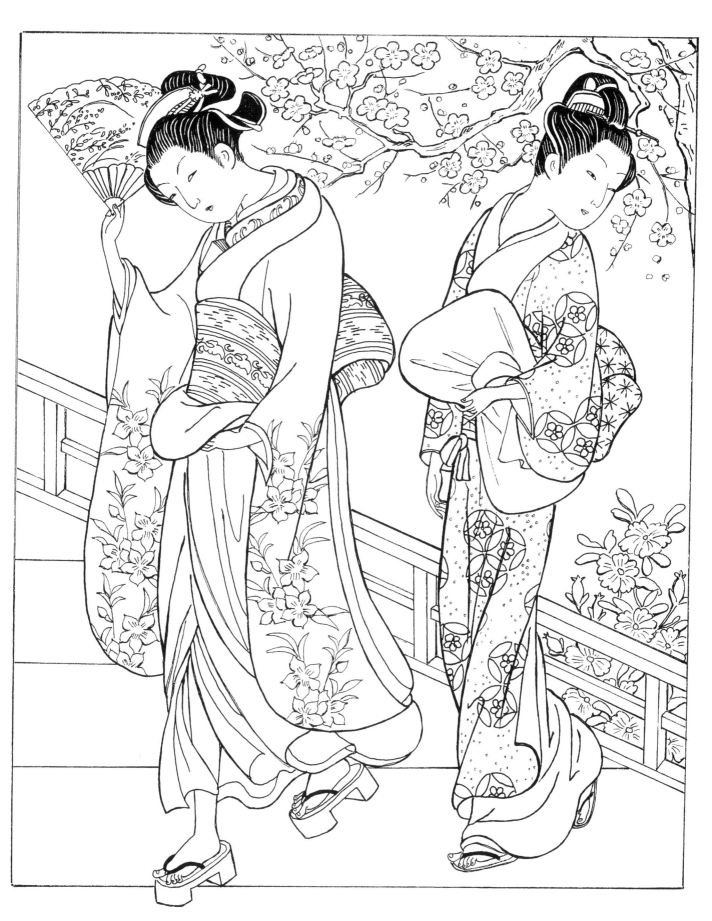

Harunobu (1725–1770). "Hazy Morning Sunlight Suggested by a Fan." A young courtesan is returning home in the morning, using her fan to shelter her from the sunlight.

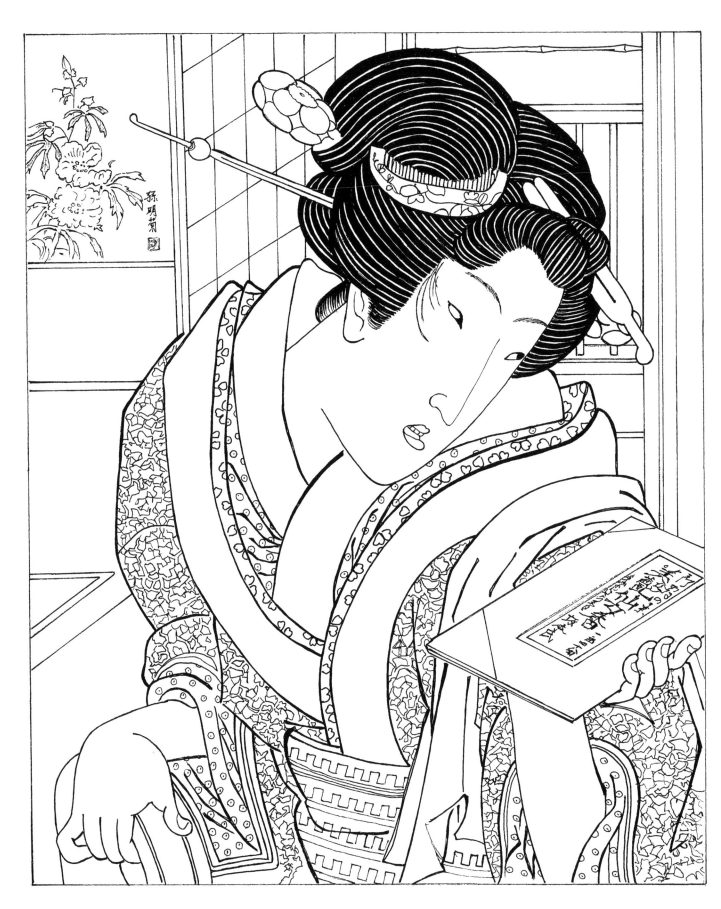

Kunisada (1786–1864). "An Array of Modern Beauties." Depictions of women in everyday life usually included beautiful clothing and furniture to create an interesting atmosphere.

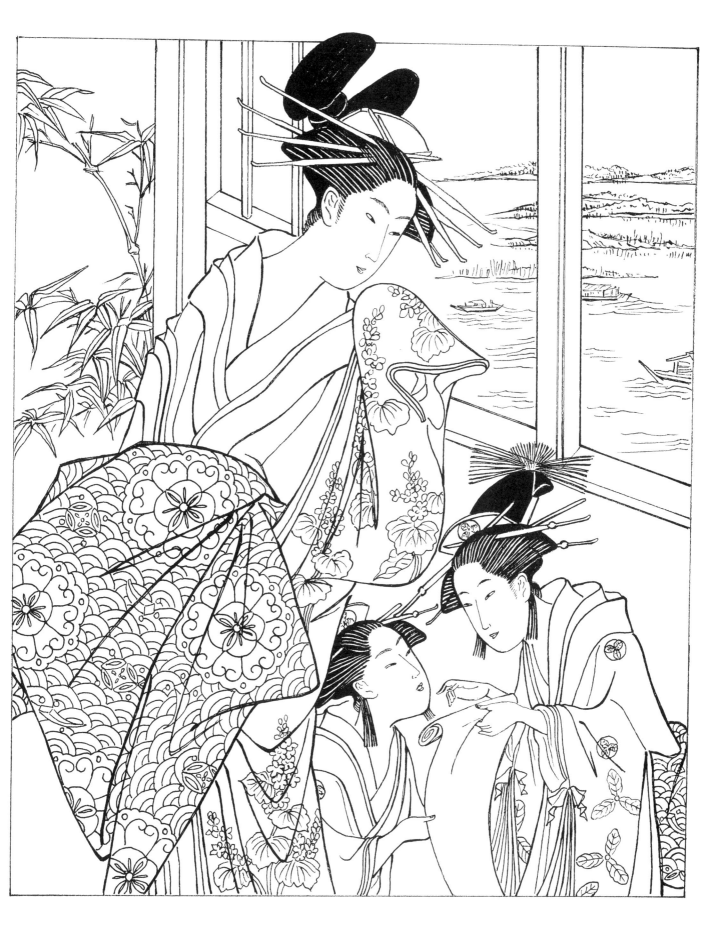

Eishi (1756–1829). "The Courtesan Nakagawa of the Matsuba-ya." The elegant woman is listening while her two young attendants read out a long letter, probably from an admirer.

17

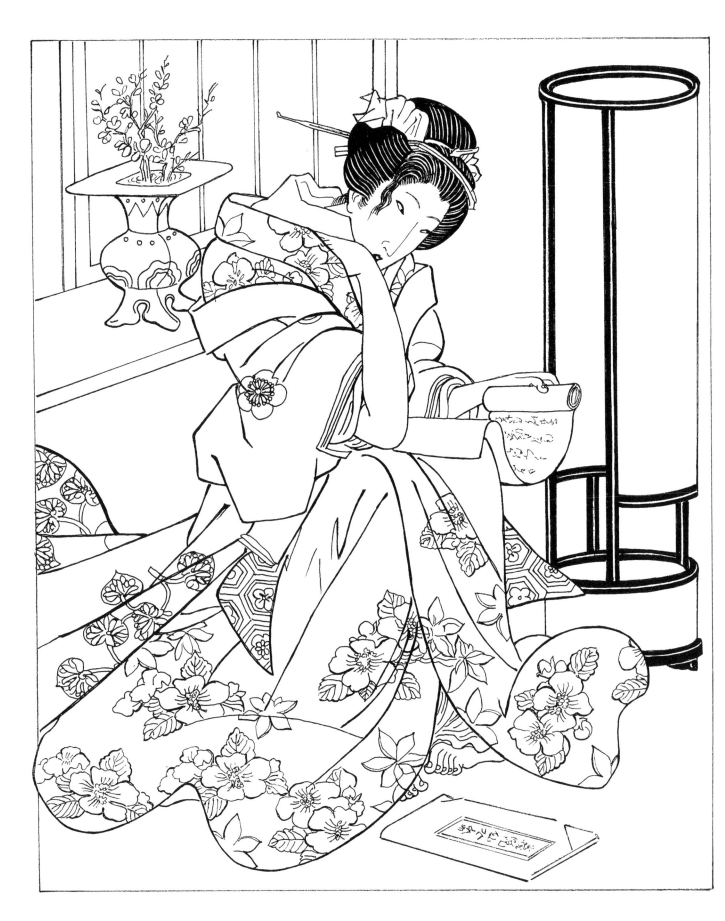

Eisen (1790–1848). "Yoshiwara Yoji Sato no Shikishi." The courtesan Nagao reads a letter next to a tall lamp. This type of quiet, intimate scene is typical of Eisen's best works.

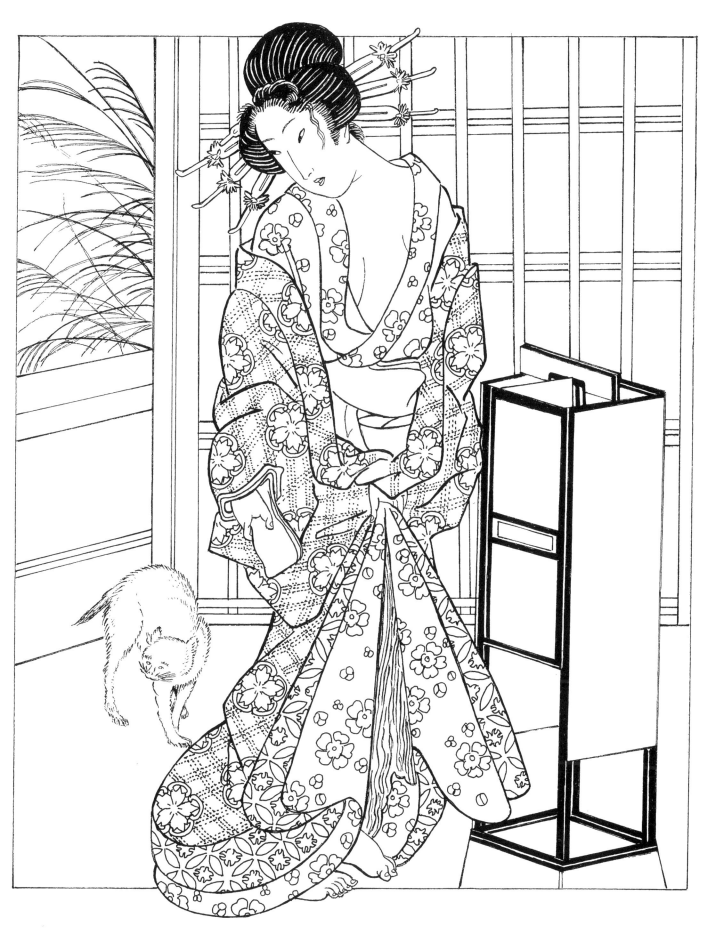

Eisen (1790–1848). "Eight Scenes in the Yoshiwara." The courtesan Komurasaki of Tamaya is seen in her private quarters wearing a beautiful kimono, pausing beside a lamp of black wood and paper.

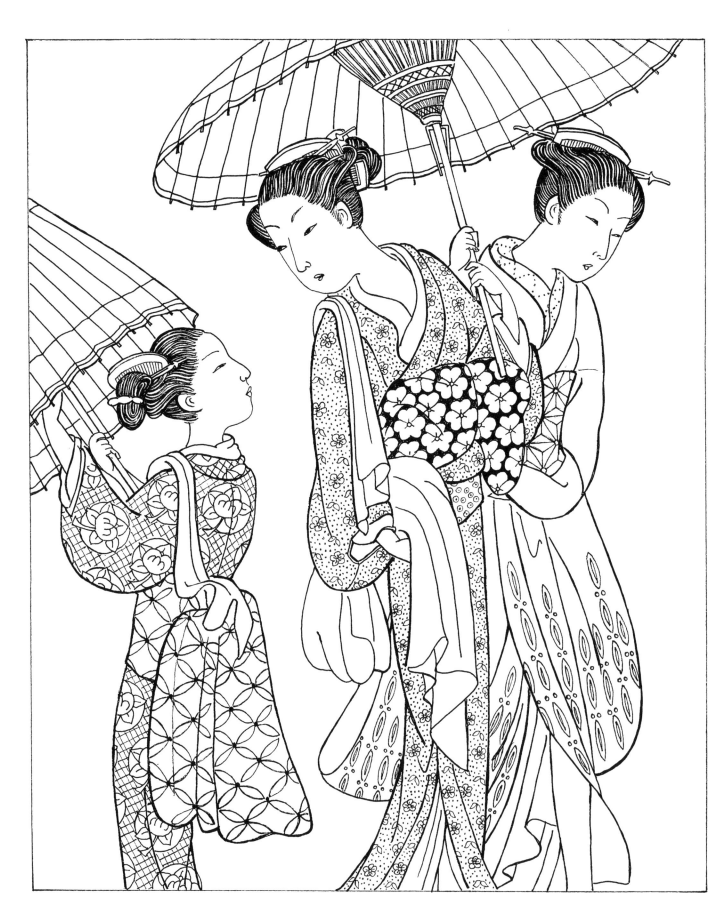

Harunobu (1725–1770). "The Fifth Month Rains." In the month of May, two young women are on their way to the bathhouse, passing a young girl who is just leaving.

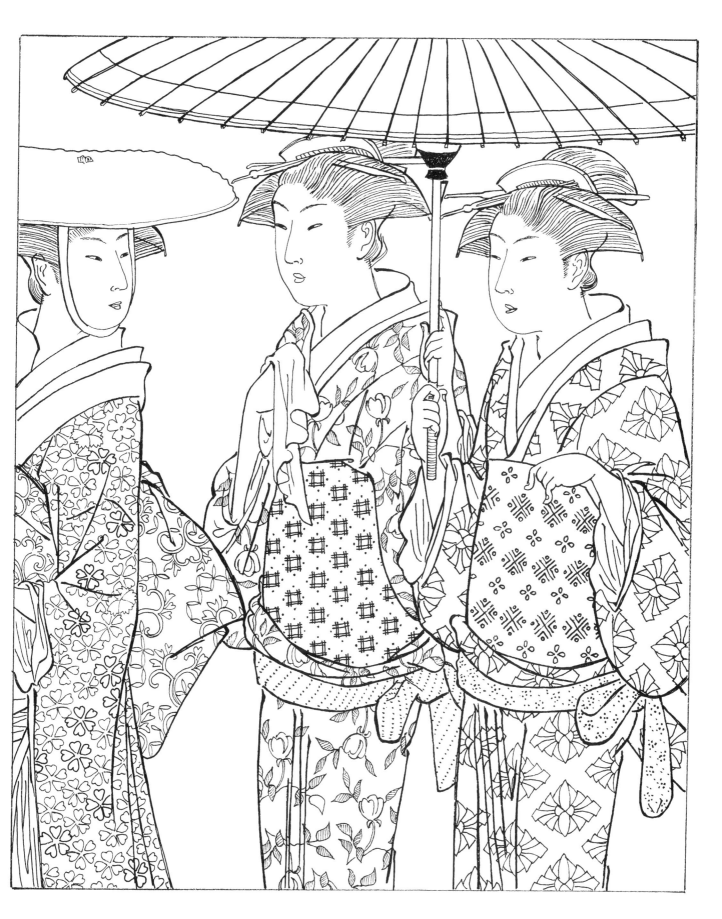

Kiyonaga (1752–1815). "A Lady With Two Servants." This print is part of a
set intended to show off the latest kimono designs and patterns of the dresses.
The umbrella is probably used to block the sun.

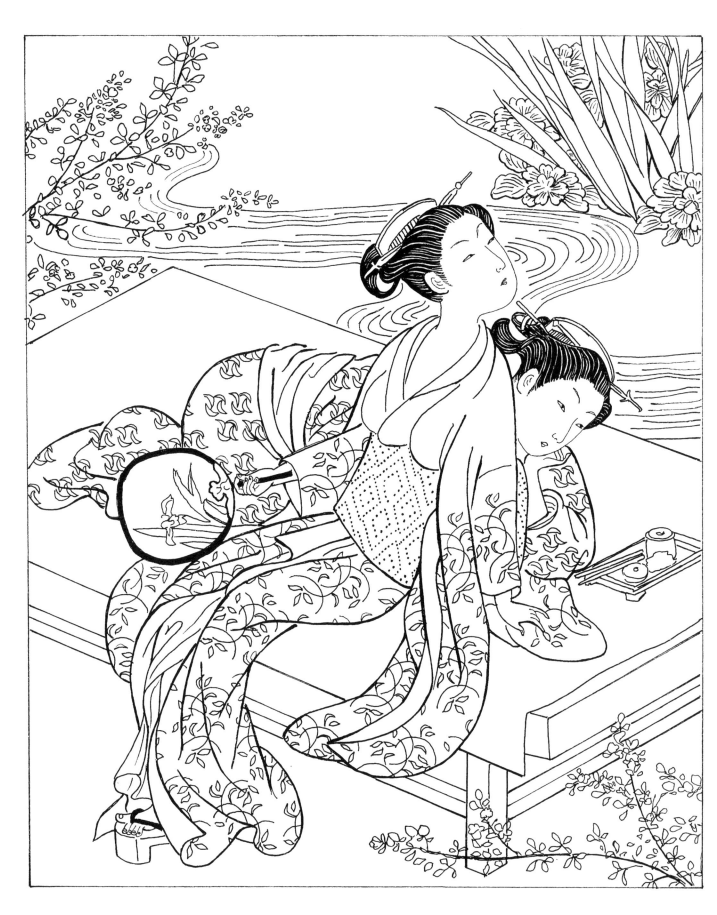

Harunobu (1725–1770). "The Eighth Month." The artist's romantic view of autumn: the flowers in bloom, a flowing stream nearby, and aromatic incense fills the night air.

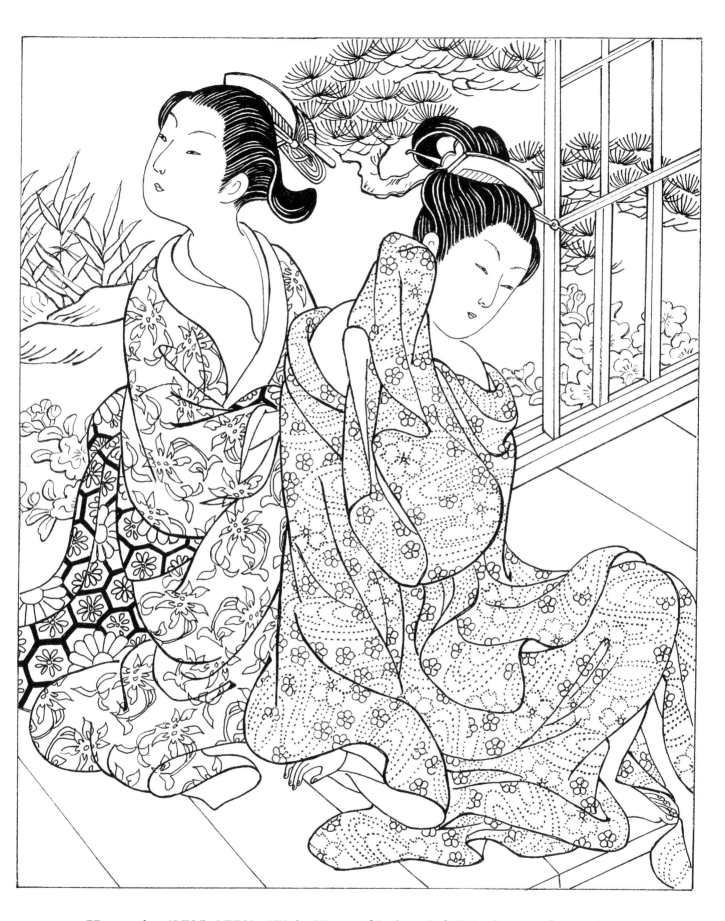

Harunobu (1725–1770). "Eight Views of Indoor Life." A glimpse of everyday life activities—the bath. The young woman on the right has just finished her bath and is in the process of drying herself off.

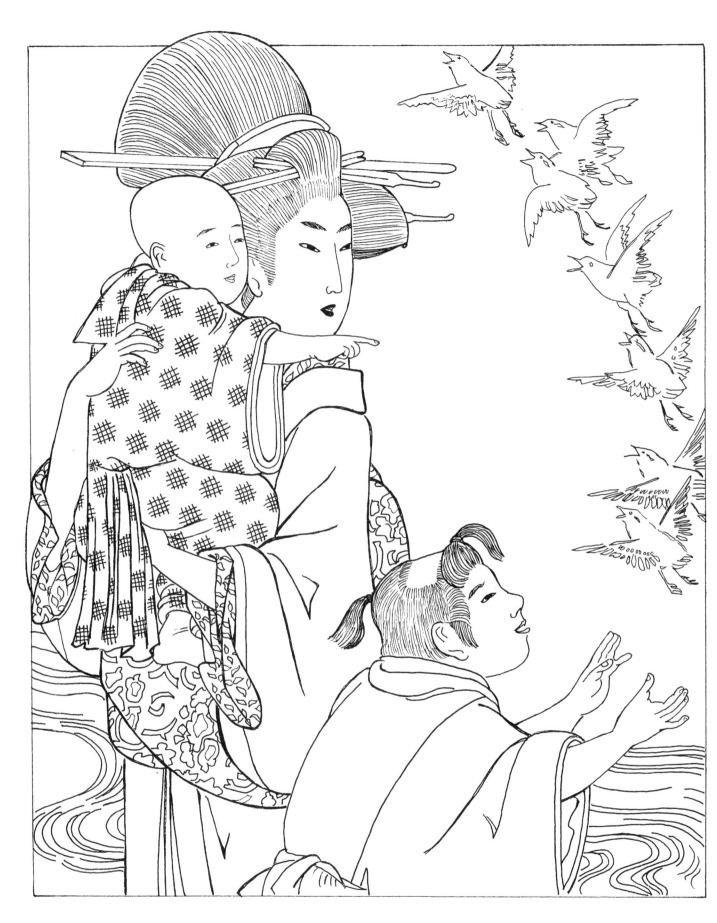

Utamaro (1753–1806). "The Six Crystal Rivers Newly Fashioned" *(detail)*. A woman and her children admire the flowing river and watch birds take flight.

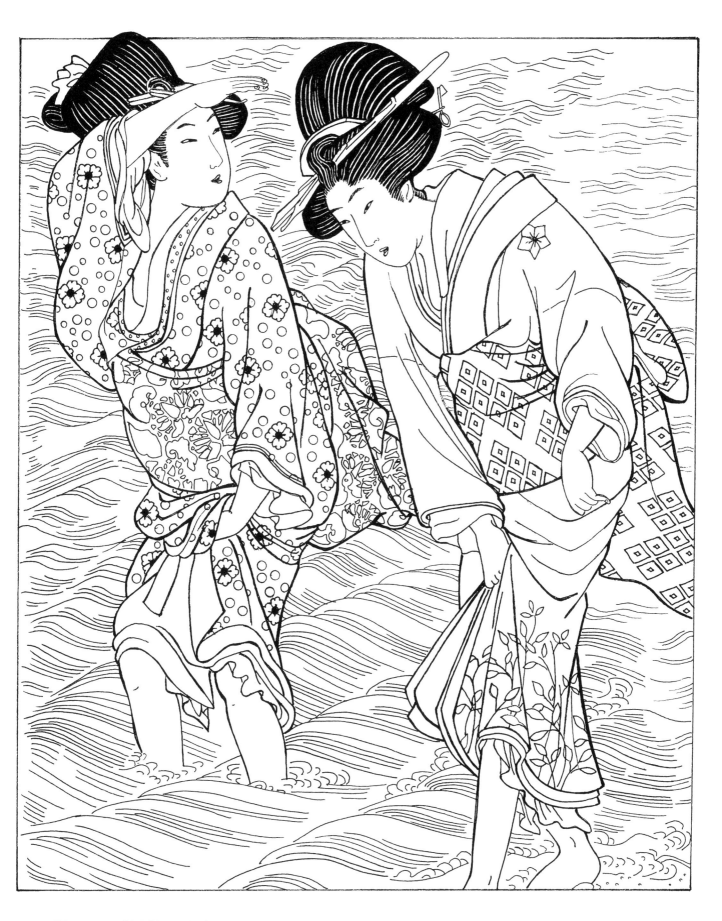

Utamaro (1753–1806). "Courtesans at the Beach at Futamigaura" *(detail)*. Two women wearing beautiful layered kimonos can't resist splashing about in the water to cool off.

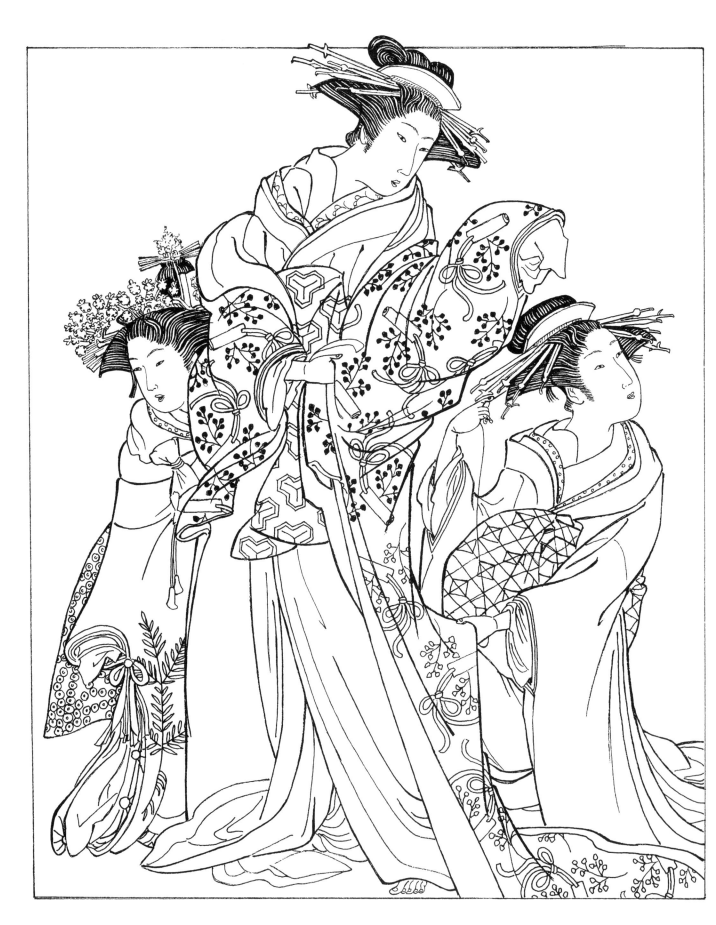

Masanobu (1761–1816). "Courtesans at Leisure." The courtesan is fully dressed, but one of her attendants is putting a finishing stitch to the elaborately patterned outer kimono.

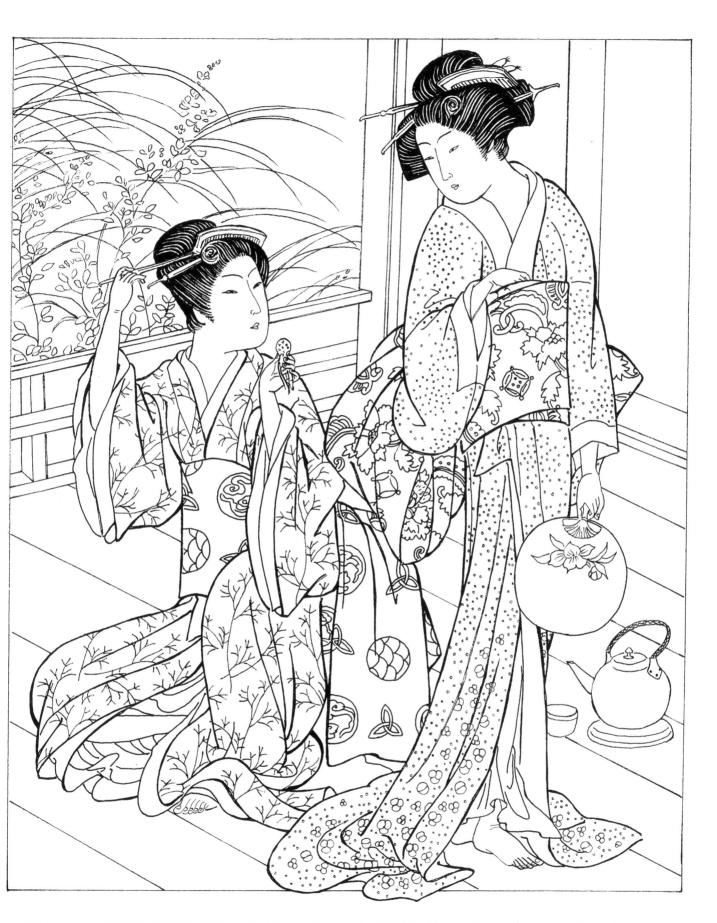

Shigemasa (1739–1820). "Two Geisha of Ryogoku." This illustration is from a series of prints on contemporary beauties. The fan the woman is holding symbolizes that the season is summer.

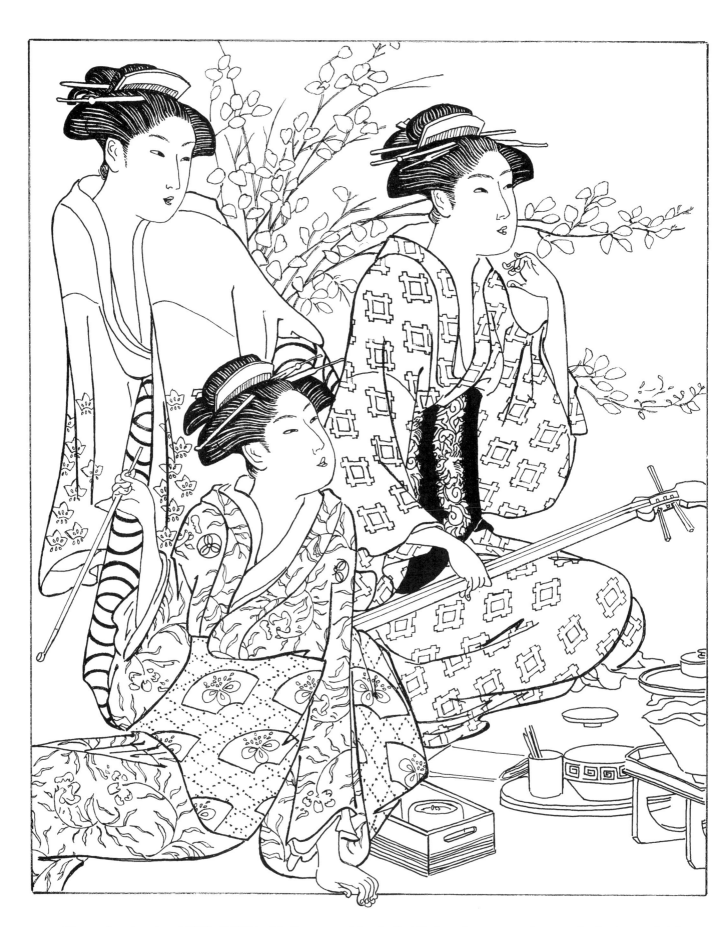

Shuncho (active 1770–1790). "A Summer Picnic." All the elements of a good picnic are laid out on a low platform: food, rice wine, a samisen for music, and a lantern for the evening.

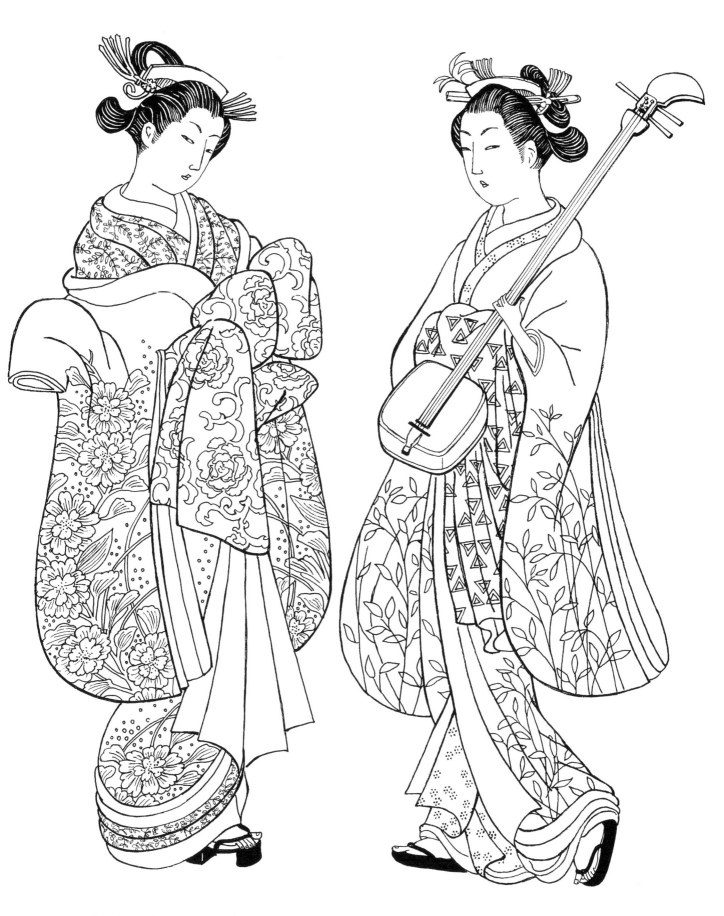

Harunobu (1725–1770). "The Seven Sages of the Bamboo Grove in Modern Guise" *(detail)*. These two women are part of a group of seven women representing an ancient Chinese poem.

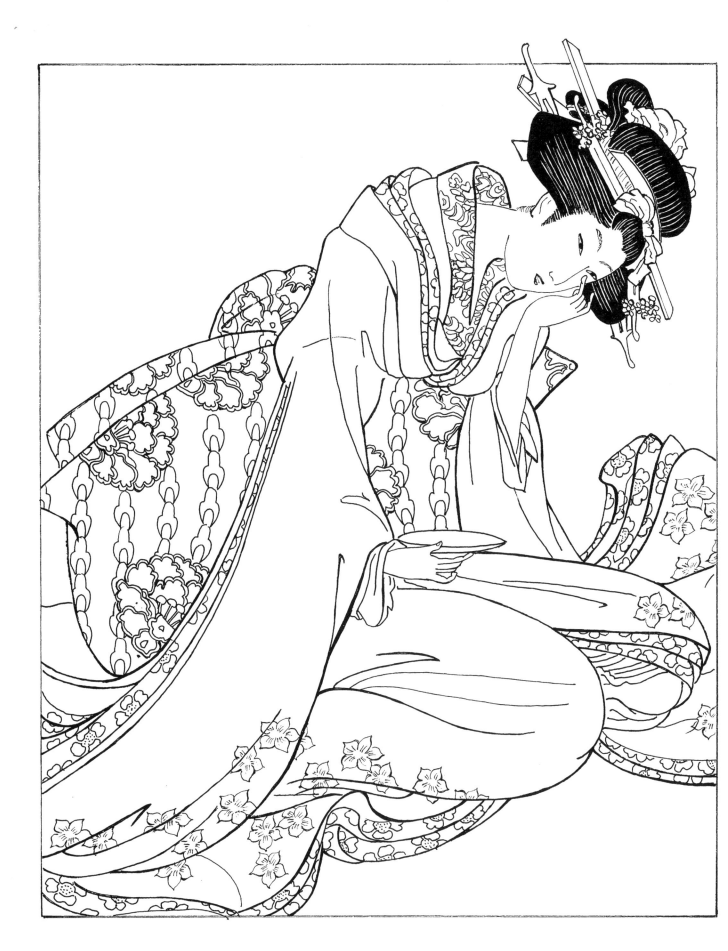

Eizan (1787–1867). "Winds of Autumn." The fall season is represented by a beautiful woman who is sipping wine from a small cup and getting tipsy.